It is with great pleasure that we present this sequel to the highly successful touring exhibition *Impressionist Masterworks from the National Gallery of Canada,* seen by over 170,000 visitors at five venues across Canada. The National Gallery is fortunate to hold such an outstanding selection of paintings that reflect the Post-Impressionists' enthusiasm for the expressive possibilities of colour and form. Included in this exhibition are works by such influential figures as Paul Cézanne, Paul Gauguin, and Vincent van Gogh. Cézanne's commanding *Portrait of a Peasant,* 1902–03, and the vigorously painted *Forest,* 1902–04, are late works from the period in which he was sought out by younger Post-Impressionist artists such as Émile Bernard and Maurice Denis. Gauguin's *Still-life,* 1886, was painted during the artist's first summer in Pont-Aven, the Breton village recognized today as the birthplace of Synthetism, and van Gogh's *Bowl with Summer Flowers* embodies his passionate discovery of the ideas of the Parisian avant-garde during that crucial summer of 1886. Representing the brilliant landscapes of the Fauve painters who emerged at the beginning of the twentieth century are Maurice Vlaminck's *Locks at Bougival,* 1906–07, and André Derain's serene view of France's Mediterranean coast *Landscape by the Sea,* 1905. Henri Matisse, a leader of the Fauve movement and a towering figure in twentieth-century art, is represented by his sensual *Nude on a Yellow Sofa* of 1926.

The superior selection of Post-Impressionist paintings represented here is a result of the National Gallery of Canada's commitment to European modernism just prior to and following the Second World War. Nine of the works in the current exhibition were acquired under Harry Orr McCurry, Director of the National Gallery from 1939 to 1955, an era described by Jean Sutherland Boggs in her book *The National Gallery of Canada* (1971) as the "Great Years of Collecting." Indeed, given the broad appeal as well as the strong demand for Post-Impressionist artists today, the choice of these particular works demonstrated exceptional foresight. The acquisition of Post-Impressionist masterpieces continued into the 1960s. In 1965 the superb *Landscape with Hooded Man,* 1903, by Maurice Denis and the splendid *Paris under Snow,* 1905–06, by Albert Marquet were purchased under the directorship of Charles Comfort. Jean Sutherland Boggs herself was newly appointed Director when Kees van Dongen's alluring *Souvenir of the Russian Opera Season,* 1909, was acquired in 1966. Robert Hubbard, Chief Curator from 1954 until 1975, also played a role in identifying potential acquisitions and encouraging interest in the Post-Impressionists. However, the National Gallery still lacks an outstanding example of Pointillism, a key artistic style of Post-Impressionism.

During the next year and a half, *Post-Impressionist Masterworks* will travel to Sherbrooke, Victoria, Edmonton, Halifax, London, and Winnipeg. Thus Canadians from coast to coast will have the opportunity to enjoy the rich heritage of paintings from this key period of art history in the collection of the National Gallery of Canada. I especially would like to thank our Board of Trustees for their ongoing support and interest in outreach initiatives; also the Department of Canadian Heritage for its assistance with the tour through the Canada Travelling Exhibitions Indemnification Program. I would like to extend my very great appreciation to Mayo Graham, Director of National Outreach and International Relations, for proposing the idea of this follow-up to *Impressionist Masterworks* as a result of her conversations with Canadian gallery directors; David Franklin, Deputy Director and Chief Curator, for his support and encouragement; John Collins, Assistant Curator, European and American Art, for writing the catalogue and overseeing preparations for the tour, and his predecessor Stephen D. Borys for making the initial selection of works for the exhibition. For their role in editing the English and French catalogues I would like to thank Janet Shorten and Bérengère de Guernon, and for her attractive catalogue design thank you to Ellen Treciokas. I also thank the following members of the National Gallery staff who have dedicated their energies and resourcefulness to the successful realization of the catalogue and tour: Daniel Amadei, Karen Colby-Stothart, Serge Thériault, Christine Feniak, Yves Théoret, Sue Lagasi, Diane Lafrance-Watier, Colleen Evans, Anne Ruggles, Guy Gratton, Diana Nemiroff, Catherine Johnston, Michael Pantazzi, James Nicholson, Martha King, Mark Paradis, Raven Amiro, and Charles Hupé.

Pierre Théberge, O.C., C.Q.
Director
National Gallery of Canada

Post-Impressionism was the term coined by the English art critic Roger Fry to serve as the title of an exhibition he organized in 1910 with Desmond MacCarthy for the Grafton Galleries in London.[1] It was a term born of frustration rather than originating from critical usage or scholarly contemplation. Pressured to come up with a title for the exhibition that would best capture the disparate variety of painting styles it included, Fry is said to have become impatient and exclaimed, "Oh, let's just call them Post-Impressionists. At any rate, they came after the Impressionists."[2]

While "Impressionism" was adopted in the 1870s by critics and artists alike, "Post-Impressionism" was unheard of until Fry coined it in 1910. Post-Impressionism thus does not apply specifically to a single painting style in the same way that Impressionism was applied, by the press of the day, to the work of the artists who appeared in the series of eight Paris exhibitions between 1874 and 1886. Rather, a number of related avant-garde styles or "isms" that all emerged in Paris at the end of the nineteenth century fall under the rubric of Post-Impressionism. These include the Pointillists, the Synthetists, the Symbolists, and the Fauvist painters.

The current *Post-Impressionist Masterworks* includes work by nine of the original twenty-six artists who exhibited at the Grafton Galleries in 1910: Paul Cézanne, Maurice Denis, André Derain, Paul Gauguin, Vincent van Gogh, Albert Marquet, Henri Matisse, Paul Sérusier, and Maurice de Vlaminck. Five additional artists have been included in the current exhibition because of their close association with Post-Impressionist circles. Pierre Bonnard and Raoul Dufy, while contemporaries of Vlaminck and Matisse, were a curious omission from Roger Fry's selection. The Englishman Walter Sickert befriended Edgar Degas in 1883 and spent much time in Dieppe; the American Maurice Prendergast studied in Paris for three years beginning in 1891; and the Dutchman Kees van Dongen resided primarily in Paris from 1897 on. These last three artists would be instrumental in disseminating Post-Impressionist ideas outside of France.

In the catalogue of the Grafton Galleries exhibition, Fry described how the generation of artists following the Impressionists became dissatisfied with the portrayal of fleeting visual effects and subtle variations of natural light.[3] For Fry the Post-Impressionist artist was above all an "expressionist" in the sense that he no longer observed nature objectively, but freely interpreted what he saw in order to convey a deeper emotional response to the subject. The break with Impressionism, however, was not an acrimonious one. Fry creates an imaginary meeting between a Post-Impressionist and an Impressionist to emphasize the close nature of their relationship: "You have explored nature in every direction, and all honour to you," says the Post-Impressionist to the Impressionist, "but your methods and principles have hindered artists from exploring and expressing that emotional significance which lies in things, and is the most important subject matter of art."[4] Such an understanding of Post-Impressionism suggests a viewer's response to painting should be compared to the response of a listener to music or poetry. Indeed, Gauguin wrote in his "Synthetic Notes," about 1889–90: "Like music, painting acts on the soul through the intermediary of the senses."[5]

The eighth and final Impressionist exhibition of 1886 could be described as an important transition in the passage from Impressionism to Post-Impressionism. Monet and Renoir had by this time left the Impressionists. Renoir had awakened to an enthusiasm for "classicism" and Monet had retired to the light-filled meadows of Giverny. Among their replacements in 1886 was the young Georges Seurat, whose moving image of leisure activity on the River Seine near Paris, *Sunday Afternoon on the Island of La Grand-Jatte*, was the largest painting (over three metres in width and two metres in height) ever to be exhibited with the Impressionists. While Seurat's subject remained compatible with the Impressionists' love of everyday life, it was painted with pure pigments applied methodically with the tip of the brush, resulting in an optical mixture of colours resolved by the

Paul Sérusier, *Landscape of the Bois d'Amour at Pont-Aven – Known as the 'Talisman'*, 1888, oil on wood, 27 x 22 cm. Musée d'Orsay, Paris

viewer's eye into contrasting form and shadow. The style is referred to as Pointillism; it was also described in 1887 as Neo-Impressionism by the critic Félix Fénéon.[6] Another new recruit was Paul Gauguin, the stockbroker turned artistic mentor who had been exhibiting with the Impressionists since 1880. In the summer of 1886 Gauguin began his first extended stay in Pont-Aven, a small village near the Brittany coast which would prove such a fruitful breeding ground for Post-Impressionist ideas.

It was in the forest of "Bois d'Amour" near Pont-Aven during the summer of 1888 that Gauguin would challenge the young student Paul Sérusier to practise an art drawn as much from his imagination as from reality, overturning the accepted academic practice of unwavering Naturalism that was still the standard of instruction at the Académie Julian where Sérusier was a student. Under Gauguin's guidance Sérusier painted a small wooden panel of the forest known as *The Talisman* (Musée d'Orsay, Paris). "How do you see these trees?" Gauguin had asked him. "They are yellow. Well then, put down yellow. And that shadow is rather blue. So render it with pure ultramarine. Those red leaves? Use vermilion."[7] With its freely subjective and emotive rendering of nature, *The Talisman* profoundly affected a number of Sérusier's fellow students at the Académie Julian in Paris. Among them were Maurice Denis and Pierre Bonnard, who would join Sérusier and others in 1888 to form a group of followers of Gauguin called the Nabis, the Hebrew word for prophets. Maurice Denis became the theoretical spokesperson of the Nabis, reaffirming Gauguin's teachings in an article published in August 1890: "Remember that a painting – before it is a battle-horse, a nude woman, or some anecdote – is essentially a flat surface covered with colours assembled in a certain order."[8] For Denis and the Nabis artists, colour harmony and compositional balance became the guiding principles of a new style of painting, referred to as Synthetism (a reference to the union of mind and material reality). With its rejection of Naturalism and emphasis on the formal aspects of painting, Synthetism remained a distinct style within the broader scope of the Symbolist movement. Nabis artists can be also considered Symbolist in the sense that their subject matter conveys spiritual meaning through a suggestive, imaginary language of visual signs or ideas.

The Grafton Galleries exhibition of 1910 included twenty-six artists, all of whom were of French origin except Vincent van Gogh (Dutch) and Pablo Picasso (Spanish). Both van Gogh and Picasso had moved to Paris in order to become acquainted with avant-garde ideas and ended up adopting France as their home. Two paintings by Picasso included in the Grafton Galleries exhibition, the Symbolist *Young Girl with a Basket of Flowers*, 1905 (private collection, New York), and the Cézanne-influenced *Portrait of Clovis Sagot*, 1909 (private collection), suggest that, for Fry, Post-Impressionism stopped short of a full-fledged embrace of Cubism. (This point of view was corrected, however, with the comprehensive representation of work by Picasso in the second Post-Impressionist exhibition of 1912.)

After the demise of the Impressionist exhibitions, self-regulated artist groups such as the Société des Artistes Indépendants played a key role in organizing exhibitions that became important venues for the appearance of new talent and stylistic innovations. Founded in 1884, the Indépendants had no jury system and were completely open to new members. It was as a participant in the fifth exhibition of the Indépendants in September 1889 that Vincent van Gogh first came to the attention of Félix Fénéon, who remained an influential supporter of Post-Impressionist artists.[9] The exhibitions of Les Vingt in Brussels, also founded in 1884, served as another vehicle to carry the ideas of the Post-Impressionists to fertile ground outside of Paris. Gauguin, Cézanne, Georges Seurat, Henri Toulouse-Lautrec, and the English Impressionist artist Walter Sickert were all invited to exhibit with Les Vingt, and at the 1890 exhibition in Brussels van Gogh would sell his first painting, the only one sold during his lifetime, for 400 francs.[10]

Maurice Denis's description of painting as "a flat surface covered with colours assembled in a certain order" is often seen as foretelling the emergence of abstract art. Indeed, the reduction of painting by Gauguin and the Nabis to its basic expressive elements made possible the bold formal innovations that preceded abstraction at the beginning of the twentieth century in the art of Henri Matisse and the "Fauves" (Wild Beasts). The Fauves were a group of painters who obtained their unusual name on the occasion of the third Salon d'Automne exhibition opened at the Grand Palais, Paris, in October 1905. Brilliantly coloured paintings by Matisse, André Derain, Albert Marquet, Maurice de Vlaminck, and others were hung in the same room with a single academic-style sculpture, prompting the art critic Louis Vauxcelles to describe the room as "Donatello surrounded by the Wild Beasts."[11] The aging Renoir, one of the Honorary Presidents of the Salon d'Automne that year, must have been amused by the critical reaction to the new direction of the Fauves, so like the scandal created by the first Impressionists thirty years earlier. While the Fauves followed no formal program, they shared a love of exuberant colour and liberal interpretation of form that resulted in paintings dominated by highly charged primary colours of red, yellow, and blue. In 1908, Matisse described his subjective approach to painting, recalling Gauguin's advice to Sérusier in 1888 to evoke his inner response to nature: "My choice of colours does not rest on any scientific theory; it is based on observation, on feeling, on the very nature of each experience."[12]

One of the principal founding figures in Roger Fry's presentation of Post-Impressionism was Paul Cézanne. According to Fry, Cézanne's painting style provided a crucial example of an artistic vision that passed from the complexity of appearances to the geometrical simplicity of nature. Between the third Impressionist exhibition of 1877 and the Exposition Universelle of 1889 Cézanne had not exhibited publicly, though he continued to paint at his principal residence in Provence and during his infrequent visits to Paris. One of the few places his work could be seen in Paris was in the small colour shop of Julien "Père" Tanguy on the rue Clauzel near the Butte Montmartre. Here, during the 1890s, Cézanne was gradually "rediscovered" by a younger generation of Post-Impressionist painters that included Maurice Denis and Émile Bernard, both of whom later visited Cézanne in Aix-en-Provence. Denis and Bernard were intrigued by the way Cézanne's work seemed to reveal evidence of the laws of artistic language, how he seemed to "construct" his paintings through the application of colour to create form. The discovery of such laws had been a goal of Gauguin and the Nabis, and something Cézanne himself sought in his work, though he never formally recorded his ideas. His "theory of art" can now only be gleaned from his surviving correspondence and the record of conversations published by visitors to his studio. After his death in 1906, Cézanne's painting continued to have a profound impact on the developments of twentieth-century art. As with the Impressionists, art dealers would play a key role in the promotion of Post-Impressionist artists. Van Gogh and his "petit boulevard" compatriots first found support among a visionary group of art dealers who operated outside of the established gallery circuit. Père Tanguy, in addition to selling art supplies, sold works by artists (such as Cézanne) who were unable to find a dealer. Théo van Gogh, Vincent's younger brother, paid Gauguin a monthly stipend in 1888 in return for paintings, an activity outside his regular duties as an employee of the conservative art dealership of Boussod, Valadon and Company. One of the few women to become involved with promoting avant-garde artists was Berthe Weill, who opened her gallery in 1901 at 25, rue Victor-Massé, where she held regular exhibitions of the Fauve painters and Picasso. Finally, a vigorous advocate of Post-Impressionism was Ambroise Vollard, who held an important exhibition of work by Cézanne at his gallery along the rue Laffitte in 1895. Vollard had a long and prosperous career as an art dealer, and amassed a considerable personal collection before

his accidental death in 1939. Three works in the current exhibition were formerly part of Vollard's collection: Cézanne's *Portrait of a Peasant* and *Forest*, and Gauguin's *Still-life*.

The 1950s emerge as the decade in which Post-Impressionism found its place at the National Gallery of Canada. Eleven of the fifteen works in this exhibition were acquired between 1946 and 1958. This interest is due in part to the end of the Second World War and the opening up of the art market, but also to an awakened enthusiasm for the art of Henri Matisse. At the twenty-fifth Venice Biennale in 1950, Matisse was recognized with a retrospective organized by the French government, and awarded the Biennale's top honour of first prize. The same year National Gallery representative Donald Buchanan visited the eighty-year-old artist in Montparnasse while Matisse was supervising work on the stained glass windows of the Dominican Chapel near Vence.[13] Impressed by Buchanan's plea that the National Gallery of Canada still did not own any of his works, Matisse offered one of his odalisque series, *Nude on a Yellow Sofa*, 1926. The painting usually hung above the dining room table in Matisse's Nice apartment but it had been lent to the Biennale retrospective, where Buchanan mentioned seeing it. Matisse replied, "Ah, yes, that would be the very thing – something solid," recalling Cézanne's remark that he wanted to make of Impressionism "quelque chose de solide, et de durable comme l'art des musées."[14] Matisse, however, would not immediately part with *Nude on a Yellow Sofa*; it was only after the artist's death in 1954 that the painting was acquired from the artist's son, Pierre Matisse, in 1958.

1. "Manet and the Post-Impressionists," Grafton Galleries, London, 8 November 1910 to 15 January 1911.
2. Desmond MacCarthy, "The Art-Quake of 1910," *The Listener*, 1 February 1945, p. 124.
3. Roger Fry, "The Post-Impressionists," Introduction to *Manet and the Post-Impressionists*, Grafton Galleries (London: Ballantyne and Company Ltd., 1910), pp. 7–8.
4. Ibid., p. 9.
5. Paul Gauguin, "Notes synthétiques," *Vers et Prose* (Henri Mahaut, 1910), cited in John Rewald, *Gauguin* (New York and Paris: Hyperion Press, 1938), p. 161.
6. Félix Fénéon, "Le néo-impressionnisme," *L'Art Moderne* (Brussels), 1 May 1887.
7. Maurice Denis, "L'influence de Paul Gauguin," *L'Occident*, no. 23 (October 1903), as cited in Bouillon 1993, p. 74.
8. Maurice Denis, "Définition du néo-traditionnisme," *Art et critique*, nos. 65 and 66 (23 and 30 August 1890), as cited in Bouillon, p. 5.
9. Félix Fénéon, "Tableaux," *La Vogue*, September 1889. Reprinted in *Oeuvres plus que complètes*, I (Geneva, 1970), p. 168.
10. Correspondence of van Gogh to his mother, Anna, 15 February 1890, as cited in Rewald, *Post-Impressionism*, p. 374.
11. Louis Vauxcelles, "Le Salon d'Automne," supplement to *Gil Blas*, 17 October 1905, [p. 2].
12. "Notes d'un peintre," *La Grande Revue*, vol. 52 (25 December 1908), as cited in Henri Matisse, *Écrits et propos sur l'art*, revised edition (Paris: Hermann, 1978), pp. 48–49.
13. Buchanan, p. 64.
14. Quoted by Maurice Denis in "Cézanne," *L'Occident* (September 1907), and cited in Maurice Denis, *Du symbolisme au classicisme: Théories* (Paris: Hermann, 1964), p. 160.

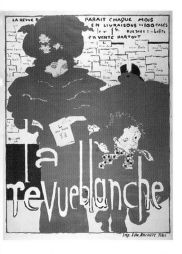

Pierre Bonnard, *La Revue Blanche*, 1894, colour lithograph on wove paper, 76 x 59 cm (image). Purchase, 1969 (14865)

1. Jean and Henry Dauberville, *Bonnard: catalogue raisonné de l'oeuvre peint*, vol. 3 (Paris: Éditions Bernheim-Jeune, 1973), p. 300.

Pierre Bonnard was a prolific illustrator and printmaker in addition to being a gifted painter known for his floating, colour-filled forms. His early career was spent in Paris under the influence of Paul Gauguin and the Nabis group of painters, which included Maurice Denis and Paul Sérusier. Today he is recognized as one of those who preserved France's grand decorative painting tradition. Bonnard was born in 1867 in the Paris suburb of Fontenay-aux-Roses to a civil servant father in the Ministry of War. Before deciding upon a career as an artist, Bonnard studied law with the intention of following his father in the civil service and gained his "licence de droit" in 1888. At the same time he pursued studies in art at the Académie Julian in Paris, and in 1887 was admitted to the École des Beaux-Arts. The year 1889 proved a decisive one for Bonnard, as he failed his civil service entrance exams but won a prestigious commission to design a poster for the wine merchants of France-Champagne. Thereafter he concentrated on paintings of interiors, landscapes, decorative designs, and printmaking. His poster design for the avant-garde journal *La Revue Blanche* incorporates into advertising art the two-dimensional surface pattern that is characteristic of the Nabis's style. In 1896, Bonnard's success seemed assured when the Impressionist dealer Durand-Ruel organized a solo exhibition of his work.

Bonnard's career was established in Paris in the 1890s, in an atmosphere heavily influenced by avant-garde ideas; his later work is dominated by the verdant and light-filled landscapes along France's Mediterranean coast, known as the Côte d'Azur. Here he pursued the colourist agenda of Nabis decorative painting to a most harmonious resolution. Bonnard began regular visits to the Côte d'Azur in 1909, often staying in Saint Tropez with his friend, the artist Paul Signac, who was a passionate yachtsman. He painted along the coast for over fifteen years, and then turned his attention to the Port of Cannes about 1923. Three years later he purchased a villa known as Le Bosquet ("The Grove") in Le Cannet, a few kilometres north of Cannes. Sailing preoccupied Bonnard at this time, and his portraits of Signac and the Hahnloser family of Switzerland in their yachts date from the mid-1920s.

While the majority of Bonnard's views of the Côte d'Azur evoke an exoticism verging on the tropical, his *Port of Cannes* is unusually overcast and cloudy – not the kind of weather to encourage yachting. Bonnard has set his easel near the shore looking south towards the sea and the Jetée Albert-Édouard which shelters the port. Bonnard's palette in this painting is uncharacteristically restricted in range, yet harmoniously balanced in the application of colour. Blue, grey-blue, and cool mauve tones are used for the clouds, sky, and many of the boats resting on shore. The sails and rigging are all stowed away, leaving a forest of brown masts rising upward towards a blustery sky – there is not a white sail to be seen. An intense ochre yellow is used to render the shoreline, broken only by the boats themselves and their shadows, perhaps an indication that the sun has not completely withdrawn. Paler streaks of orange and brown along the horizon above the bay further suggest the sun's waning presence. Left of centre near the shore a lone figure in blue sits contemplatively in a floating boat, while beyond, the silhouettes of larger craft hint vaguely at the wealth and popularity of Cannes as a celebrated Riviera resort town for the aristocracy of Europe.

Bonnard lived at Villa Le Bosquet until his death in 1947, and it is more often the intimate world of his immediate surroundings on the heights above Cannes than the city itself that appears in his paintings. Bonnard does not seem to have owned a yacht himself, and with the death of Signac in 1935 he became less interested in the sport as a painting subject. *The Port of Cannes* was exhibited the year it was painted at the Bernheim-Jeune gallery in Paris as *Port Orageux*, and the gallery acquired it from the artist in 1928. Having passed through the collection of Georges Renand, Paris, and the Galerie Pétridès, Paris, it was sold to the National Gallery of Canada in 1952 by E. J. van Wisselingh and Company of Amsterdam.[1]

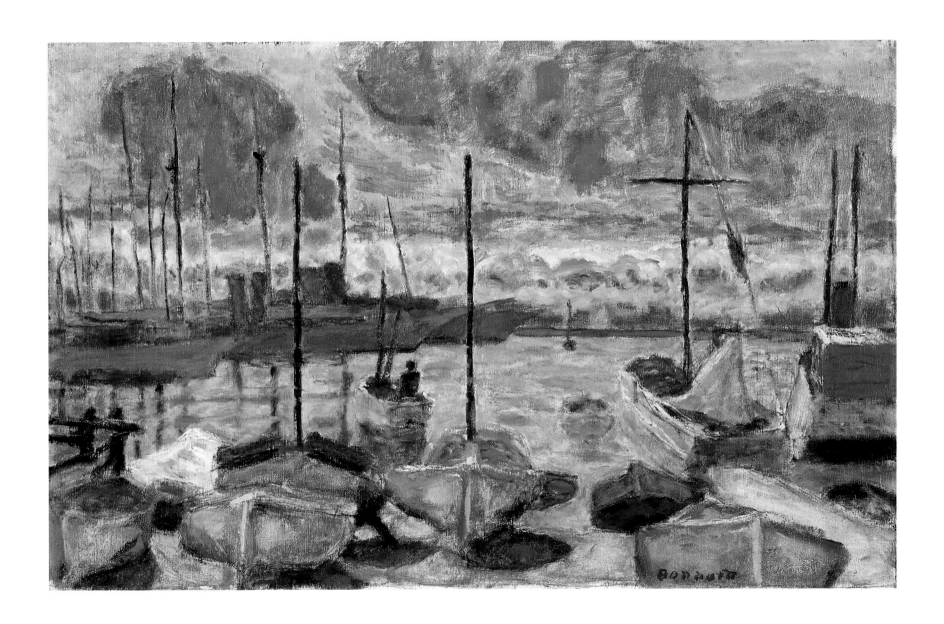

Pierre Bonnard (French, 1867–1947), *The Port of Cannes*, 1927, oil on canvas, 41 x 65 cm. Purchase, 1952 (5879)

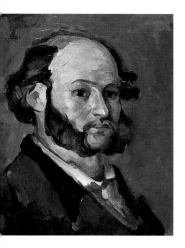

Paul Cézanne, *Portrait of Gustave Boyer*, c. 1870-71, oil on canvas, 46 x 38 cm. Purchase, 1940 (4550)

Paul Cézanne is an artist who can be discussed equally well within the contexts of Impressionism and Post-Impressionism; indeed, his importance to the development of twentieth-century art has long been recognized. What concerned Cézanne in his painting were the universal rules that determined artistic expression; this may be one reason that his work appealed to the younger generation who gathered around Gauguin. Like many of the artists in this exhibition who came from middle-class backgrounds, Cézanne forsook a career that promised a comfortable and secure living. In his case, law studies and a future role in his father's banking business in Aix-en-Provence were abandoned in order to follow the more arduous path of avant-garde painter – a choice made less punitive by the regular allowance he received from his father and an inheritance that left him sufficiently independent that sales of paintings became financially inconsequential.

Unlike Pierre-Auguste Renoir or Édouard Manet, Cézanne rarely hired professional models. For his figure and portrait painting he more often chose close friends such as Gustave Boyer, family members, or the anonymous citizens of his hometown of Aix-en-Provence. Cézanne drew upon the "peasant" model most notably for his celebrated series of *Card Players* during the mid-1890s. However, the word "peasant" seems inappropriate for the man in *Portrait of a Peasant*, as it ignores his urban dress, his carefully knotted tie, and his tailored overcoat. It has been suggested that the model worked for Cézanne as a gardener. The heavy blue overcoat he wears would have been practical for outdoor work in the cooler winter months, and he has the large hands of a labourer.

Cézanne painted this figure in a studio he built on a rise of land called Les Lauves, just north of the town of Aix. The same green and brown wall treatment used in the background of this work can be seen in a painting of the *Gardener Vallier* (1904–06, private collection), painted just before he died in 1906. Since Cézanne began to use this studio in September 1902, it is possible that the *Portrait of a Peasant* dates from the winter of 1902–03.[1] The figure is brought as far forward as possible so that his ankles as well as the chair legs below are cropped out of the picture plane. The symmetry of the pose derives from the frontal point of view, the curved line of the coat arms, the centred placement of his folded hands and crossed legs. The intersecting diagonals of the background elements of the floor, and the odd angled placement of the chair and the mat it sits on, introduce a contrasting visual dynamic. All lines seem calculated to give a sense of balance to the composition – even the small portfolio at right leaning against the wall plays its role in calming the movement of the eye.

1. Isabelle Cahn, "Chronology," in Cachin 1996, p. 561.

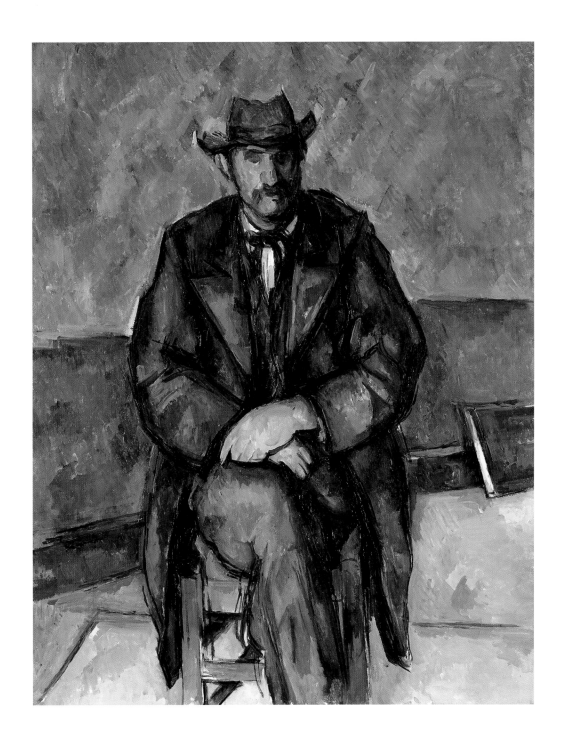

Paul Cézanne (French, 1839–1906), *Portrait of a Peasant*, 1902–03, oil on canvas, 92.7 x 73.7 cm. Purchase, 1950 (5769)

Paul Cézanne, *Road at Auvers-sur-Oise*,
1873–74, oil on canvas, 55 x 46 cm.
Purchase, 1946 (4637)

In 1861 Cézanne followed his school friend, the writer Émile Zola, to Paris. Here he saw the annual Salon exhibition of paintings for the first time, and attended the Académie Suisse, an unsupervised studio established to give artists an opportunity to study the model. He met Camille Pissarro, one of the founders of the Impressionist movement, who mentored Cézanne in plein-air painting in 1872 and encouraged his emerging Impressionist style in such works as *Road at Auvers-sur-Oise*. Over the next twenty years Cézanne would travel frequently between Paris and Provence, finally settling in Provence in 1899.

It has been suggested that *The Forest* represents the bank of the roadway at the entrance to the grounds of Château Noir, a wooded estate near Aix where Cézanne often painted and which he tried unsuccessfully to purchase for himself in 1899.[1] The rich red soil of the region is evident in this view of the road which opens into a clearing sheltered by tall parasol pines. It is an unusual choice of subject because it lacks a clear centre of interest. Yet we can see that Cézanne still follows the Impressionist lesson of Camille Pissarro: he transforms the seemingly banal into a composition with a startling visual balance of colour and line. The horizontal bed of the road is placed just below the midpoint of the canvas and is emphasized by the horizontal layers of ground that fall towards the viewer. The trunks of the pines that soar above the road provide a vertical counterpoint to the lower half of the canvas. The paint colour is applied to reinforce the principal linear structures of the painting. A shallow, flat brushstroke is used for the yellow and orange pigments of the bank and exposed earth below, while the trees above are painted with three or four shades of green and are remarkable for their sharp, thin appearance. The darker pigments of shaded foliage to the right and left frame the scene, contrasting with the more brightly lit central open area. Using his characteristic "constructive stroke," by which paint is applied in tightly compacted patch-like sections, Cézanne has further enhanced the rhythm of the composition through a network of strokes angled to the left. For Cézanne,

form could not be separated from colour; rather, he felt, they enhance one another. As he told Émile Bernard: "There is no line; there is no modelling; there are only contrasts. Black and white do not provide these contrasts; the colour sensations do. Modelling results from the perfect rapport of colours. When they are juxtaposed harmoniously, and when they are all present and complete, the painting models itself."[2] The paintings of Paul Cézanne provide the best example of the Post-Impressionist artist's search for a painting style that reflected the universal truths of art, yet also constituted genuine self-expression.

1. Isabelle Cahn, "Chronology," in Cachin 1996, p. 558.
2. Émile Bernard, "Paul Cézanne," *L'Occident*, no. 32 (July 1904), as cited in Michael Doran (editor), *Conversations with Cézanne* (Berkeley: University of California Press, 2001), pp. 38–39.

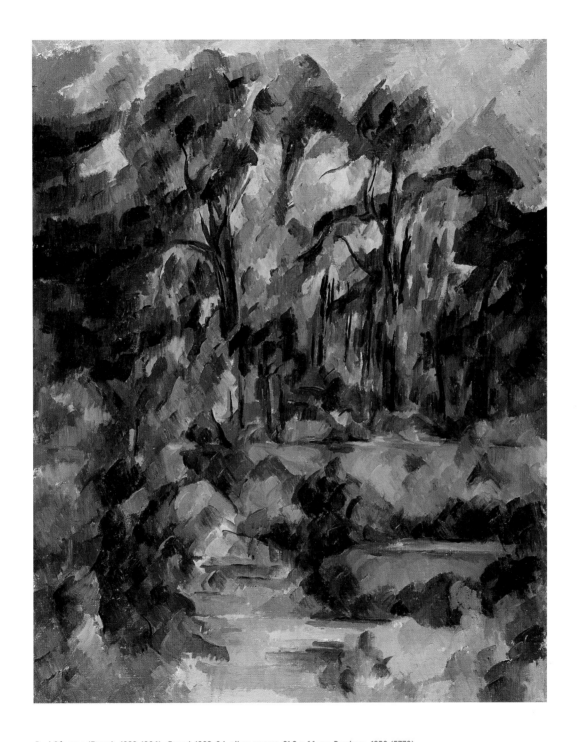

Paul Cézanne (French, 1839–1906), *Forest*, 1902–04, oil on canvas, 81.9 x 66 cm. Purchase, 1950 (5770)

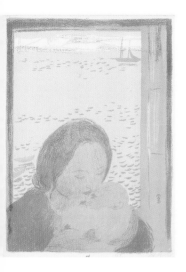

Maurice Denis, *Motherhood before the Sea*, 1900, colour lithograph on wove paper, 36 x 27.7 cm. Purchase, 1974 (18052)

1. Maurice Denis, "Définition du néo-traditionnisme," *Art et critique*, nos. 65 and 66 (23 and 30 August 1890), as cited in Bouillon 1993, p. 5.
2. Correspondence from Dominique Maurice Denis to Charles Jerdein, June 1964, Curatorial File, National Gallery of Canada.
3. Maurice Denis, *Journal*, vol. 1 (Paris: La Colombe, 1957), p. 170.
4. Ibid, pp. 183–99.

Born in 1870 in Normandy, where his father, a railway company official, had retreated during the Franco-Prussian War, Denis lived most of his life in the town of Saint-Germain-en-Laye, just west of Paris. A museum now located in the town is dedicated to the study of his work and times. While studying at the Académie Julian, Denis was impressed by Paul Sérusier's report of working with Gauguin in Brittany during the summer of 1888. Soon afterwards Denis joined Sérusier and a number of fellow students, including Pierre Bonnard, in a group calling themselves the Nabis, and became an important spokesperson for their ideas. In 1890, at twenty years of age, he wrote "Definition of Neo-Traditionism," an essay critical of the Naturalist aesthetic. The essay opens with his now-famous line, "We should remember that a picture – before being a war horse, a nude woman, or telling some other story – is essentially a flat surface covered with colours assembled in a certain order."[1] At the beginning of the twentieth century Denis sought out Paul Cézanne in Aix-en-Provence, and his record of the visit remains a crucial document for understanding the late work of this reclusive painter.

Denis was an artist of strong Catholic faith, whose paintings often depict subjects of religious allegory in idyllic or pastoral settings suggestive of the Middle Ages. Principal among the motifs that recur in Denis's work during the Nabis period is the "Bois Sacré" or "Sacred Wood," a setting common to paintings with religious or mythological themes and characterized by a meditative forest interior. A comparison can be drawn between the dense forest growth of *Landscape with Hooded Man* and the motif of the sacred wood; however, the line between imagination and reality is here deliberately blurred. The painting has no clear religious theme, yet the foreground figure making his way through fern-covered undergrowth is dressed like a monk in a hooded sackcloth robe. Farther down the slope and to the right a barefoot figure leads a single cow through the forest to some unknown destination. The sense of mystery is further enhanced by the ethereal pale blue of the tree trunks and the ominous clouds hovering above the cultivated landscape beyond. All the landscape elements suggest a withdrawal from the reality of daily urban life save for a distant cottage whose roof is barely visible through the trees at the bottom of the forested slope.

For all its suggestive fantasy, the landscape in this painting is thought to be inspired by the rugged coastline of Brittany, where Denis often vacationed with his family, and which is possibly the locale for his lithograph *Motherhood before the Sea*. According to the son of the artist, the forest lies near the town of Perros-Guirec, situated on a point of land jutting into the English Channel.[2] If this is indeed true, the body of water seen through the trees would be the cove of Perros, here appearing light blue in the sun's reflected rays. Denis had visited the small fishing port as early as 1892, had married his fiancée Marthe Meurier there the next year, and in 1908 would buy a villa in the town known as "Silencio." The countryside attracted him not only by its isolated beauty, but also by its importance as an area with an ancient history. In 1901, while riding his bicycle near Loctudy on the Atlantic coast of Brittany, he marvelled that the Romans could have built roads there, and remarked in his journal that there must have been a "hybrid Gallo-Roman civilization in this region, as a result of reciprocal sacrifices."[3]

There is no indication in Denis's *Journals* that he vacationed in Perros in 1903.[4] Rather, the entries that year are filled with vivid observations of his visit to the religious community in the Benedictine monastery of Beuron in southern Germany. Beuron became an important centre for the revival of religious arts in the late nineteenth century, making its influence felt as far away as Paris and Vienna. Inspired by Beuron's example, Denis himself was to found the "Atelier des Arts Sacré" in 1919. Something of Denis's enthusiasm for the devotional life he witnessed in Beuron may have been the motivation for *Landscape with Hooded Man*, combined with a countryside that was dear to his heart.

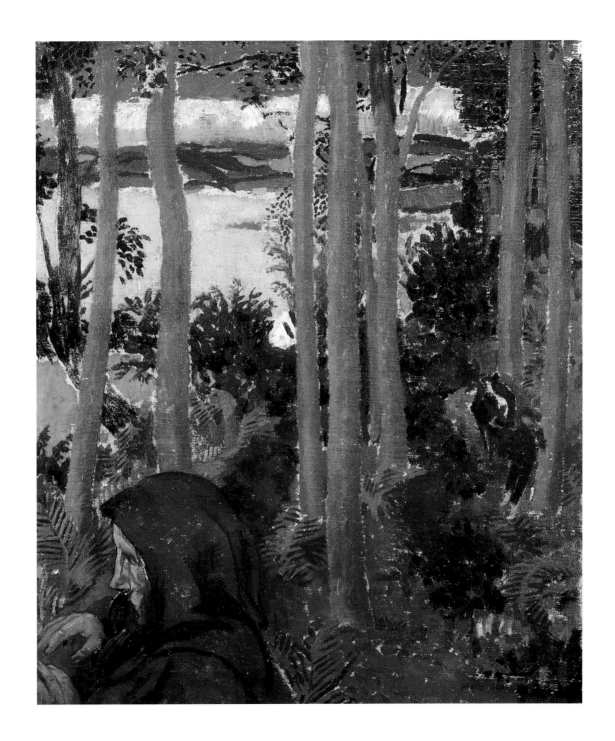

Maurice Denis (French, 1870–1943), *Landscape with Hooded Man*, 1903, oil on canvas, 63.6 x 53.5 cm. Purchase, 1965 (14854).

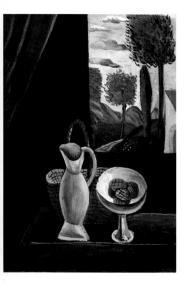

André Derain, *Still-life*, c. 1912–14, oil on canvas, 93.7 × 67 cm. Purchase, 1956 (6435)
© Estate of André Derain / Sodrac (Montreal) 2002

André Derain was born in Chatou, a village on the Seine northwest of Paris. In the 1880s, Chatou was a popular destination for Parisian cultural society, notably Pierre-August Renoir and Guy de Maupassant, and celebrated for its annual rowing regattas. Except for three years of military service (1901–1904), Derain lived in Chatou from 1900 until 1907. In 1900 he met another future Fauvist colleague, Maurice de Vlaminck, with whom he shared a studio that year. Vlaminck also continued to live and paint in the area; thus the pair gained the informal name of the "School of Chatou." Son of a baker, by 1898 Derain was studying at the Académie Camillo under Eugène Carrière. *Landscape by the Sea* was painted during a period when Derain's career was gaining some success. In February 1905 Henri Matisse had introduced Derain to the art dealer Ambroise Vollard, who soon afterwards purchased the contents of his studio and contracted Derain to provide work for his gallery. Three paintings sold at the Salon des Indépendants that spring (reportedly to someone seeking to demonstrate the worst of contemporary art).

The location of *Landscape by the Sea* has been the subject of some debate, sparked by differing opinions on the resemblance of the scene to various locations along the Côte d'Azur. Published in 1949 simply as *Paysage au bord de la mer* (1905), it was purchased by the National Gallery in 1952 with the subtitle *Côte d'Azur près Agay*, Agay being a coastal village south of Cannes known for its sheltered port.[1] It has also been suggested that the locale is near L'Estaque, where Derain is known to have painted in 1906, but in a recent catalogue of the artist's complete paintings it is given the title *Bord de Mer à Cassis*, Cassis being a few kilometres east of Marseilles.[2] Derain may have travelled through Marseilles in August 1905 on his return to Paris from Collioure, a French coastal town near the Spanish border where he had been painting with Henri Matisse in the intense summer heat of July and August. Matisse had spent the previous summer in Saint-Tropez, west of Cannes, with Pointillist painter Paul Signac, and the next summer decided to return to the south of France. *Landscape by the Sea* was among twenty-eight paintings Derain completed in July and August, before returning to Paris in early September.[3]

The summer of 1905 at Collioure had been a revelation for Derain and Matisse. Both began to paint with bolder masses of colour. While *Landscape by the Sea* is undated and the exact location along the Côte d'Azur remains unresolved, it unquestionably shares the brilliant tonalities that Derain discovered during those summer months. Over a cream-coloured ground, he has layered pale complementary tones of green, cadmium yellow, pink, and blue to evoke the sensation of warm light bathing the rugged Côte d'Azur. In the foreground stand trunks of sparsely planted trees, misshapen by the strong mistral winds of southern France. By 1912, however, Derain had fallen under the influence of Cubism and adopted a darker palette and an interest in spatial relationships such as those seen in *Still-life* of c. 1912–14.

1. Georges Duthuit, *Les Fauves* (Geneva: Éditions des Trois Collines, 1949), p. 32, and correspondence from E. J. van Wisselingh and Co., Amsterdam, 14 March 1952, in the Curatorial File of the National Gallery of Canada.
2. Identified as l'Estaque in *L'Estaque, naissance du paysage moderne, 1870–1910* (Marseille: Musées de Marseille, 1994), p. 172, and as Cassis by Michel Kellermann, *André Derain. Catalogue Raisonné de l'oeuvre peint*, vol. 1 (Paris: Éditions Galerie Schmit, 1992), p. 41.
3. Kellermann, pp. 31–46.

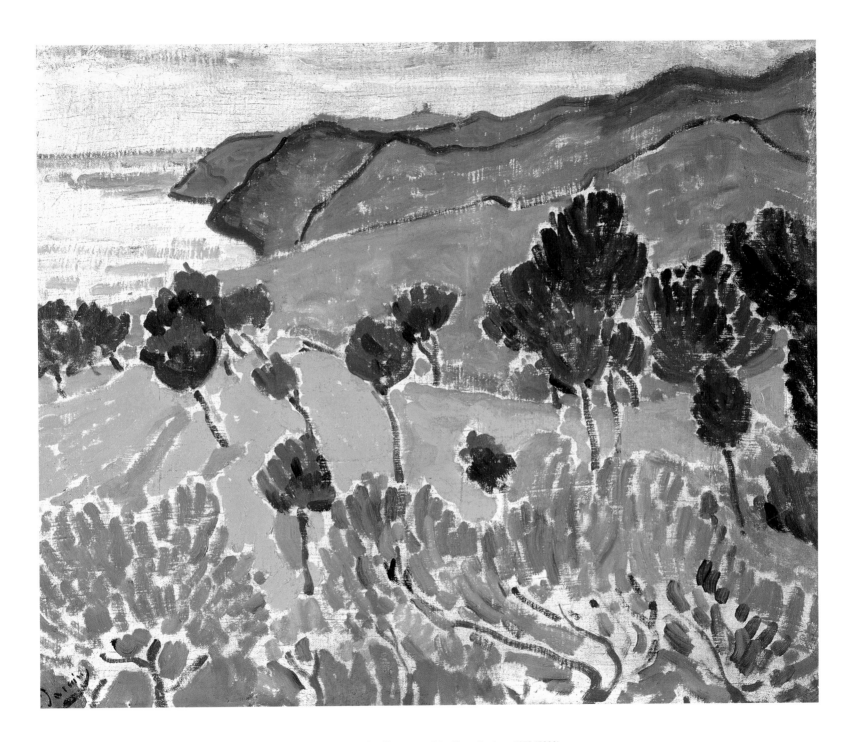

André Derain (French, 1880-1954), *Landscape by the Sea: the Côte d'Azur near Agay*, 1905, oil on canvas, 54 x 65 cm. Purchase, 1952 (5880)
© Estate of André Derain / Sodrac (Montreal) 2002

Kees (Cornelis) van Dongen was born in the village of Delfshaven near Rotterdam, where his father owned two small factories that dried grain and spices from Indonesia. Van Dongen initially began working in the family business, but entered the Academy of Fine Arts in Rotterdam in 1892, where he studied before heading to Paris in 1897. He quickly gained recognition, participating in a group show at the Galerie le Barc de Boutteville. By 1901 he was living in Montmartre with his wife and making a living as an illustrator for journals – including *Le Rire, Gil-Blas*, and *L'Assiette au beurre*. His favourite subjects for painting included the circus, the theatre, and the dance hall. In 1904, the art dealer Ambroise Vollard organized an exhibition of over one hundred of his works, with a catalogue introduction by the influential art critic Félix Fénéon. By 1906 van Dongen had met Maurice de Vlaminck and André Derain, and his painting reflected the Fauve concern with colour and dramatic form. Van Dongen became a French citizen in 1929 and lived most of his adult life in France.

Van Dongen's painting *Souvenir of the Russian Opera Season* commemorates the premiere in Paris of Sergei Diaghilev's renowned dance company, the Ballet Russe, which performed at the Théâtre du Châtelet as part of a Russian opera and dance series held during the first two weeks of June 1909.[1] Among the sensations of the "saison russe" was the one-act "drame choréographique" *Cléopâtre*, first presented by the Ballet Russe the evening of 4 June, and reportedly inspired by Théophile Gautier's novella of Ancient Egypt, *Une Nuit de Cléopâtre* (1838).[2] This piece was the only one to feature Ida Rubenstein, who danced the title role and is identified on the back of the canvas as the reclining figure in the painting. Rubenstein was a wealthy amateur known for her androgynous looks, whose only previous stage experience was as Salomé in Diaghilev's St. Petersburg production the year before. The critic of *Le Figaro*, Robert Brussel, was impressed with Rubenstein's ability to express the rhythm and gesture of Egypt.[3] The standing dancer with outstretched arms is also identified by an inscription on the back of the canvas; she is Anna Pavlova, a dancer celebrated for her graceful movements. The plot of the piece centred on the fatal seduction by Cleopatra of the young Prince Amoun. Betrothed to Princess Tahor as danced by Pavlova, the Prince was obliged to drink poison after betraying his love in the Queen's embrace. The sweeping red arcs in Van Dongen's painting most likely refer to the series of brightly coloured veils unwound from Rubenstein's body before the seduction began.

The Russian artist Léon Bakst, who designed the sets and costumes of *Cléopâtre*, was praised by Brussel for the "brutal ardour of his tonalities." The electric mood created by Bakst's use of strong colours is provocatively suggested in van Dongen's painting. The blue background may be a symbolic reference to the colour of Cleopatra's hair and also that of the twelfth and final veil that fell from her body. Inspired by the modern dance of Isadora Duncan, who performed in St. Petersburg in 1907, *Cléopâtre* was noted by *Le Figaro* for its attempt to merge music, dance, and art. But it was above all the mystery of ancient Egypt that inspired choreographer Mikhail Fokine, who later wrote, "I had only one thing in mind: Egypt and the wonderful beauty of its art. . . . These profile positions, angular lines, and flat palms were sustained all through the ballet."[4] While closely related to the Bakst designs, Van Dongen's free application of colour in a Fauvist style, to evoke rather than describe, is a clear indication of his interest in Fauvism.

1. This painting has been discussed previously by Jean Sutherland Boggs in "Van Dongen's *Souvenir de la Saison d'Opéra Russe, 1909," The National Gallery of Canada Bulletin*, vol. 6, no. 11 (1968), pp. 14-19.
2. Robert Brussel, "La Saison Russe," *Le Figaro*, 5 June 1909.
3 Ibid.
4. Michel Fokine, *Memoirs of a Ballet Master* (Boston and Toronto: Little Brown, 1961), p. 127.

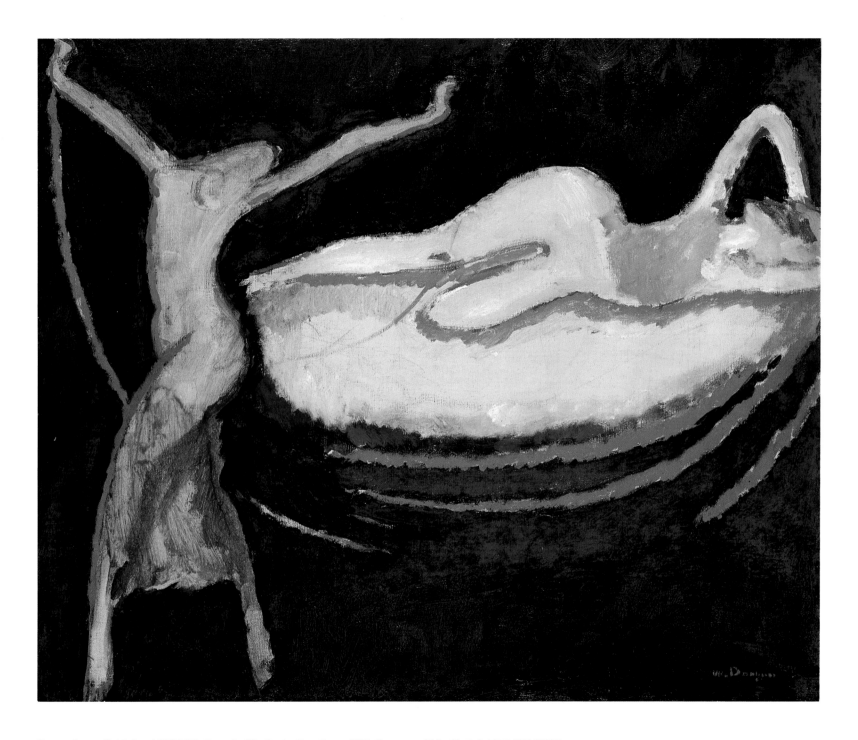

Kees van Dongen (Dutch, French 1877–1968), *Souvenir of the Russian Opera Season*, 1909, oil on canvas, 54.2 x 65 cm. Purchase, 1966 (14984)

While employed during his teens as a bookkeeper, Raoul Dufy pursued studies at the municipal art school in his hometown of Le Havre. He won a scholarship from the school in 1900, and then registered at the École des Beaux-Arts in Paris as a student of the portrait painter Léon Bonnat. In Paris he was introduced to a multitude of artistic influences. His experience of Matisse and the Fauves prompted Dufy to adopt a brighter palette and a looser brushwork, which departed dramatically from the dry academic style of Bonnat. Dufy produced textile designs in 1911 for the fashion designer Paul Poiret, and would remain involved with printmaking, illustration, and mural painting. During the 1910s Dufy moved towards the more whimsical, calligraphic style that he is best known for today. This style animates his painting of Saint-Paul-de-Vence, one of the many works inspired by his travels in southern France. Another of these is *Côte d'Azur*, c. 1935.

Saint-Paul-de-Vence is built upon a hill amidst the rolling countryside near Nice and the Côte d'Azur, a region known for its cypress trees and its orange and olive groves. The fortified appearance of the perimeter dates to Saint-Paul's strategic military importance at the beginning of the sixteenth century under François I. A popular destination for artists and writers in the 1920s, it is noted today as the home of the modern art collection of the Fondation Maeght. Between 1920 and 1923 Dufy painted some thirty-five views of Saint-Paul-de-Vence and its surroundings, including several almost identical views of the larger town of Vence, just four kilometres to the north. The two towns are often confused, as they share the same picturesque architecture and centralized plan surrounding a prominent Romanesque church spire.

Dufy's decorative sensibility is evident in the broad areas of colour and patterned, decorative planes that dominate the composition. While the artist worked from nature, exact transcription of what he saw was not necessary. Shapes and colour were important to him only insofar as they evoked what has been described as a kind of shorthand of nature and experience.[1]

Indeed, his portrayal of Saint-Paul is almost magical in its elevated, panoramic sweep of the town without a clear indication of how this viewpoint is achieved, though undoubtedly it was painted from one of the surrounding hills. The interlocking roofs of the town's houses recall the Provençal landscapes of Paul Cézanne, whose retrospective at the Salon d'Automne in 1907 deeply influenced Dufy.

Raoul Dufy, *Côte d'Azur*, c. 1935, water-colour and gouache on wove paper. Gift of Dennis Molnar, 1978 (18956)
© Estate of Raoul Dufy / Sodrac (Montreal) 2002

1. Marcelle Berr de Turique, "Les aquarelles de Raoul Dufy," in Fanny Guillon-Lafaille, *Raoul Dufy. Catalogue raisonné des aquarelles, gouaches et pastels*, vol. 1 (Paris: Éditions Louis Carré, 1891), p. xv.

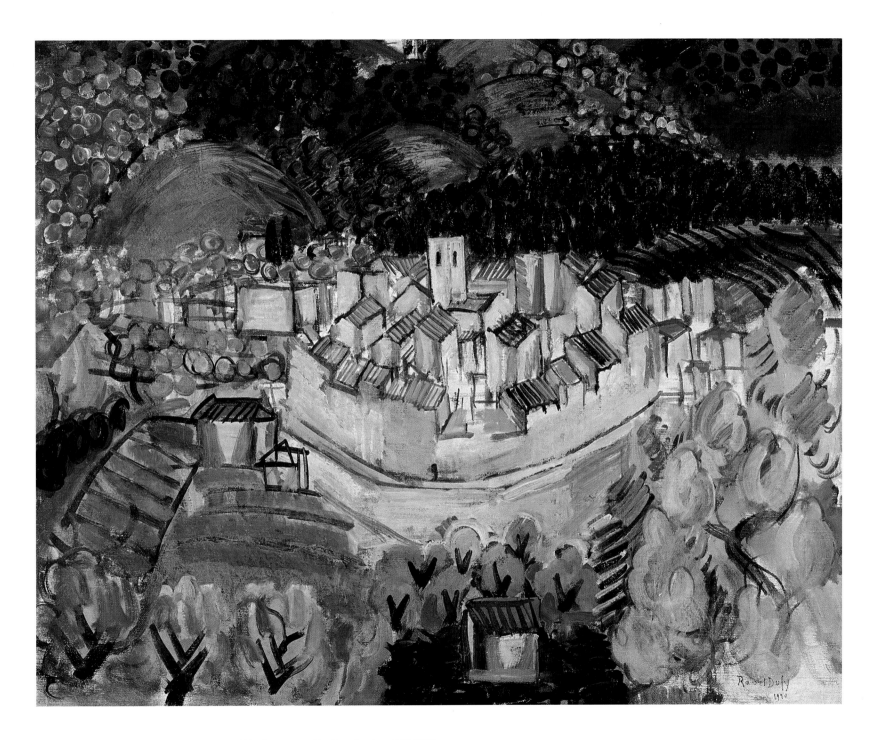

Raoul Dufy (French, 1877–1953), *Saint-Paul-de-Vence*, 1920, oil on canvas, 65 x 81 cm. Purchase, 1955 (6385)
© Estate of Raoul Dufy / Sodrac (Montreal) 2002

As a stockbroker in the 1870s Paul Gauguin began to paint Impressionist-style landscapes under the influence of Camille Pissarro. Following the stock market crash of 1882 Gauguin decided to leave the Parisian financial world and become a full-time painter. He had little formal training, preferring to work directly with Pissarro, who was instrumental in arranging Gauguin's participation in the Impressionist exhibitions beginning in 1880. By 1888, Gauguin had established himself as a leader of avant-garde ideas in Paris and had attracted a group of younger artists, including Paul Sérusier and Maurice Denis, who called themselves the Nabis. Gauguin died penniless and in ill health in the Marquesas in 1903, leaving behind a compelling and beautiful series of paintings that document his life and dreams in the South Seas, dating from his first visit to Tahiti in 1891.

In severe financial straits and seeking an economical way of life that would allow him to continue painting, Gauguin first visited Pont-Aven in July 1886, following the close of the last Impressionist exhibition on 15 June. A nondescript village near the rugged Atlantic coast of Brittany, Pont-Aven attracted few visitors other than the colony of artists who had been gathering there for decades during the summer. Gauguin would write of his love of Brittany in 1888: "I find wildness and primitiveness there. When my wooden shoes ring on this granite, I hear the muffled, dull, powerful tone I seek in my painting"[1] From mid-July to mid-October 1886 the Breton folk and countryside inspired some twenty canvases, including this small, jewel-like *Still-life* painted at the Pont-Aven pension owned by Marie-Jeanne Gloanec.[2]

At the edge of a rounded wooden table with enough of a finish to reflect the light, Gauguin has placed a white bowl holding brightly coloured red nasturiums, and fleshy pink blossoms that might be roses. A broad green leaf lying on the table keeps the setting from becoming too orderly. The table sits before a wall of pale blue and pink, inscribed in the upper right with a floating floral decoration. Next to the flowers on the table is a bulbous-

shaped drinking vase of local make known as a "biberon," or baby bottle, with its handle turned towards the viewer. Gauguin has placed one or two floral stems below the rim of the vase so that, combined with the position of its handle and painted decoration, they contribute to a vague suggestion of human facial features. The biberon intrigued Gauguin and he included it in another still-life, *La Nappe Blanche*, or *White Tablecloth*, signed, dated 1886, and inscribed "Pont Aven, Pension Gloanec," a work the artist gave to Mme Gloanec, perhaps in return for room and board.[3]

Paul Gauguin, *The Quarries of Le Chou near Pontoise*, 1882, oil on canvas, 59.4 x 73 cm. Purchase, with the assistance of a gift from H. S. Southam, Ottawa, 1947 (4842)

1. Victor Merlhès (editor), *Correspondance de Paul Gauguin: documents, témoignages* (Paris: Fondation Singer-Polignac, 1984), p. 172.
2. See also the discussion in Bogomila Welsh-Ovcharov, "Two Breton Encounters: Paul Gauguin at the National Gallery of Canada," *National Gallery of Canada Review*, volume 3 (Ottawa, 2002).
3. Wildenstein 2001, vol. 1, pp. 270–73.

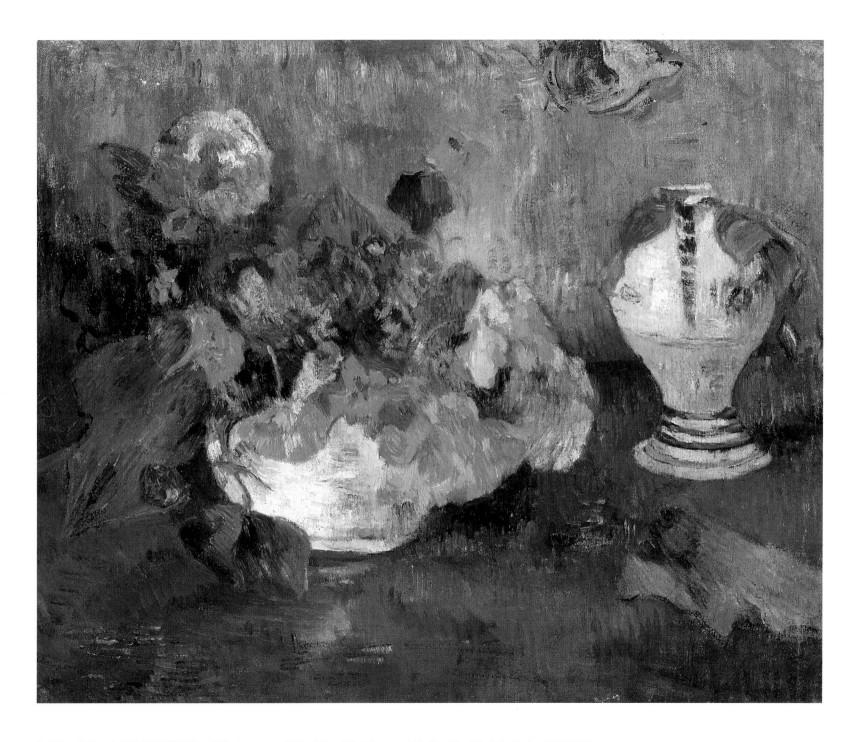

Paul Gauguin (French, 1848–1903), *Still-life*, c. 1886, oil on canvas, 33.2 x 41.1 cm. Gift of Jeanne and Léontine Vollard, Ile-de-la-Réunion, 1950 (4995)

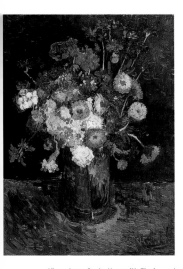

Vincent van Gogh, *Vase with Zinnias and Geraniums (Still-life I)*, 1886, oil on canvas, 61 x 45.9 cm. Purchase, 1950 (5045)

1. As cited in Jan Hulsker, *The Complete Van Gogh: Paintings, Drawings, Sketches* (Oxford: Phaidon, 1980), p. 234.
2. *The Complete Letters of Vincent van Gogh*, vol. 2 (Boston and Toronto: Bullfinch, 1991), letter 459a, p. 513.
3. Ibid., vol. 3, letter R47, p. 406. See also discussion in Collins 1999, pp. 6–9.

Vincent van Gogh was born 30 March 1853 in Zundert, North Brabant, in The Netherlands, the son of a Dutch Reformed minister and a bookbinder's daughter. At the age of 16 van Gogh was engaged by the Hague branch of the French firm of art dealers Goupil and Company, formerly the business of his retired uncle and namesake, Vincent van Gogh. In January 1876 he was dismissed from the firm after it was bought out by Boussod, Valadon, and Company. The next four years proved difficult ones for van Gogh as he explored other vocations, first as a schoolteacher and then as a missionary to coal miners in south-west Belgium. In 1880 he decided to become an artist; he moved to Brussels in October, hoping to enter an artist's studio and work at the academy. After several years of painting in the Netherlands, van Gogh moved to Paris in 1886, having become intrigued by the pioneering work of the Impressionists.

Van Gogh soon became immersed in the progressive ideas about colour theory that were being discussed among the Parisian avant-garde. In a letter thought to date from late July 1886, his brother Théo, with whom he was staying, wrote to their mother that Vincent was "mainly painting flowers – with the object to put a more lively color into his next pictures He has acquaintances who give him a collection of flowers every week which serve him as models."[1] Over the summer months of 1886, van Gogh painted some thirty floral still-lifes and his description of them as "these gymnastics" suggests the degree of his experimentation during this brief period.[2] *Bowl with Summer Flowers* is one of two examples from this period owned by the National Gallery of Canada.

The floral arrangement of *Bowl with Summer Flowers* is layered generously and exuberantly with paint, leaving the bouquet with a surface of thick impasto that reflects van Gogh's interest in the style of the Provençal painter Adolphe Monticelli. *Bowl with Summer Flowers* is set against a smooth background of dark red ochre mixed with black. With its central position and strong horizontal division between table and wall, the painting anticipates the artist's later, more celebrated series of *Sunflowers* of 1888–89. While emulating Monticelli's overworked and tactile brushwork, van Gogh's still-life paintings of the summer of 1886 also address the colour theories advocated by the art critic Charles Blanc, whose popular book *Grammaire des arts du dessin*, first published in 1867, was into its seventh edition by 1888. It is known that van Gogh purchased a copy of Blanc's treatise about August 1884 and that the book prompted him to make more of an effort to use complementary colours in the Paris still-lifes.[3] *Bowl with Summer Flowers* exhibits complementary tones in the contrast of an orange blossom with small blue flowers, possibly cornflowers.

Vincent van Gogh (Dutch, 1853–1890), *Bowl with Summer Flowers (Still-life II)*, 1886, oil on canvas, 50.2 x 61 cm. Purchase, 1951 (5808)

Albert Marquet was born in Bordeaux in 1875, the son of a railway employee. At the age of 15, he moved to Paris with his mother and enrolled in the École des Arts Décoratifs. To support her son's studies, Marquet's mother sold land that she had inherited and opened a shop in Paris called "Jours et Broderies" (hemstitching and embroidery).[1] In 1892, Marquet met Henri Matisse at the École des Arts Décoratifs when the elder artist enrolled to prepare for the exams at the École des Beaux-Arts. Matisse greatly influenced the direction of Marquet's career as an artist. Marquet was accepted into the École des Beaux-Arts in 1894, Matisse the year after, and they studied together in the studio of Gustave Moreau. Marquet met many of the future Fauve painters at Moreau's studio, and he participated with them in the notorious exhibition at the Salon d'Automne of 1905 where the group earned their name.

Paris under Snow shows the busy streets of the student quarter of the Left Bank, not far from the Sorbonne to the south and the École des Beaux-Arts farther west. To the right the Quai Saint-Michel runs east along the left bank of the Seine towards Notre-Dame Cathedral. Across the river on the opposite bank are the buildings housing the Prefecture of Police. In the foreground the Pont Saint-Michel crosses the Seine and runs south into the Place Saint-Michel. To paint *Paris under Snow*, Marquet has positioned himself facing the busy intersection of Place Saint-Michel, most likely in the upper floors of his own apartment at 25, Quai des Augustins, his address in the Salon des Indépendants catalogues of 1905 and 1906.

Beginning about 1900, Matisse and Marquet began painting elevated street scenes from the windows of their apartments or a room in a cheap hotel. *Paris under Snow* was inspired by Matisse's dramatic views of Notre-Dame painted from the apartment at 19, Quai Saint-Michel, where he had lived from as early as 1892. Matisse particularly favoured Notre-Dame, as it represented his notion of what defined the city of Paris: "I never tire of it – for me it is always new."[2] He particularly enjoyed the view after returning from travel in southern France. Marquet clearly shared Matisse's enthusiasm for the Notre-Dame subject, as he repeatedly returned to it from a variety of viewpoints. In 1908, following the death of his mother, Marquet would take over Matisse's studio at 19, Quai Saint-Michel.

Marquet accurately captures the relentless humidity of Parisian winters. An overcast sky transforms the city into a dull monotone punctuated only by the whites of a fresh layer of wet snow (Matisse later joked that Marquet used grey because he was so poor he couldn't afford colours). Despite the unyielding gloom of *Paris under Snow*, however, colour is present in the soft pinks of the paved surface of Place Saint-Michel, the single strokes of dark blue that suffice for pedestrians, the contrast of pale blue tones in the sky, the ochre brown of the Prefecture of Police building, and the pure grey of Notre-Dame's silhouette. Across the bridge a stroke of red accents the signage of a public tram.

Albert Marquet, *Small Square with Street Lamp,* Paris, c. 1904, oil on canvas, 60 x 73 cm. Purchase, 1956 (6488)

1. Michèle Paret, "Biographie d'Albert Marquet," in *Albert Marquet* 1875-1947 (Lausanne: Fondation de l'Hermitage, 1988), p. 36.
2. "Interview with Ragnar Hoppe, 1919," as cited in Flam 1995, p. 74.

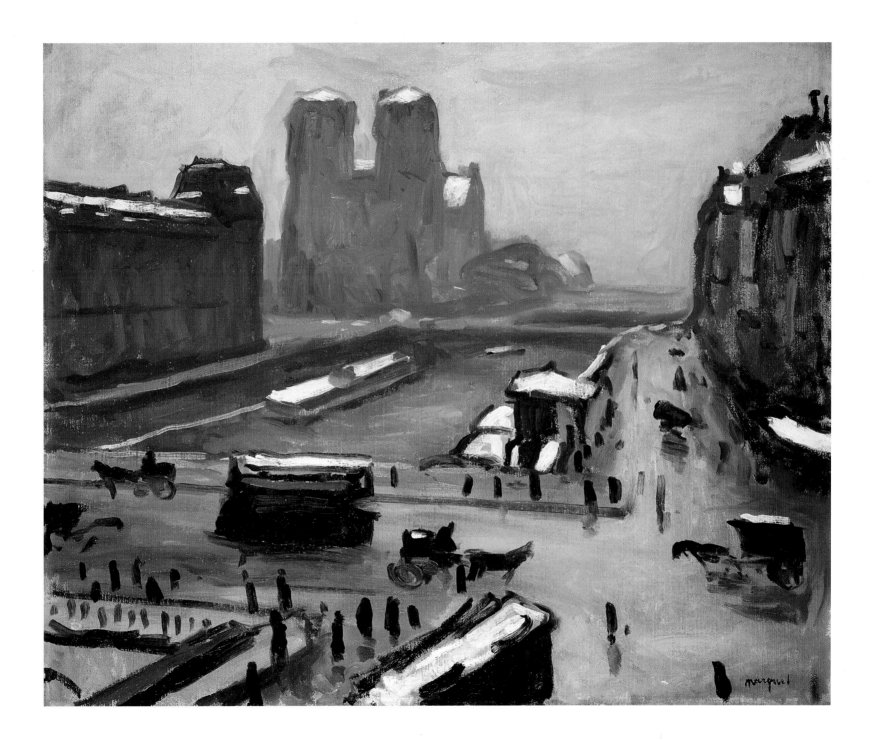

Albert Marquet (French 1875–1947), *Paris under Snow*, c. 1905–06, oil on canvas, 60.2 x 73.2 cm. Purchase, 1965 (14816)

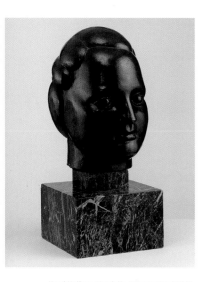

Henri Matisse, *Henriette II (Large Head)*, 1927, bronze on a marble base, 32 cm high (without base). Purchase, 1955 (6428)
© H. Matisse Estate (Paris) / Sodart 2002

Henri Matisse was born in Le Cateau-Cambrésis near Cambrai, Picardy, in northern France on New Year's Eve 1869, the son of a hardware and grain merchant. By 1887 he was registered as a law student in Paris, and two years later began work in a law office in Saint-Quentin, while also taking classes in drawing at the municipal art school. Against his father's wishes, Matisse gave up his law career in 1891 and entered the Académie Julian in Paris to prepare for the École des Beaux-Arts entrance exam, which he passed in 1895. Matisse became a leading member of the Fauve group of painters at the beginning of the twentieth century and held an influential position on the jury of the Salon d'Automne in 1908, when he rejected Georges Braque's Cubist-influenced landscapes. In the 1920s Matisse spent the winter season in Nice and finally settled there in 1928.

The odalisque is arguably one of the most consistent and recognizable of Matisse motifs. The present work belongs to a series of reclining figures in exotic and oriental dress that Matisse painted over the decade 1918 through 1928. About 1930 Matisse told an interviewer: "As for the odalisques, I saw them in Morocco, which makes it possible for me to paint them in France without playing make-believe "[1] He had travelled to Morocco on two occasions in 1912. The comment reveals that Matisse considered his subject to be a contemporary one despite a venerable nineteenth-century tradition of orientalized odalisques in the work of Eugène Delacroix and Jean-Auguste-Dominique Ingres. As a modernist who embraced everyday life, Matisse may have felt obliged to defend his choice of subject in this way. He would return to the odalisque subject throughout the rest of his life, which suggests that the memory of North Africa was a potent inspiration for Matisse.

While the theme of the odalisque is redolent with oriental connotations, the setting and décor of *Nude on a Yellow Sofa* are rather eccentric than explicitly exotic. Photographs of Matisse's studio and apartment in the 1920s show an eclectic mix of comfortably upholstered chairs, large floral-patterned wallpaper, oriental rugs, and Moorish wall hangings. In the painting the figure reclines on a chaise longue which is draped in bright yellow fabric with a repeating pattern of laurel wreaths. Her head and shoulders are supported by a folded blue and red coverlet or garment. Under her hips lies a thick sheet of white cloth. Behind is a folding screen decorated with bold pink blossoms and scrolling green stems. Soft sunlight bathes the figure from the right, creating an alternating series of cool and warm flesh tones. The sensual curve of the model's thigh and calf is accented with a blue floral anklet.

The model for the majority of odalisque paintings from 1920 until 1927 was the young art student Henriette Darricarrère (born 1901), whose family lived near Matisse's rented hotel rooms in Nice. Matisse would also portray her features in the three versions of his sculpture bust *Henriette*, 1925–29. *Nude on a Yellow Sofa* remained a personal favourite of Matisse until his death in 1954. It can be seen hanging unframed above Matisse and his wife in a photograph taken of the couple in their dining room about 1929.[2] Matisse often lent the painting to important exhibitions, including the Carnegie International exhibition of 1936 and a major retrospective at the Venice Biennale in 1950, where it impressed *Canadian Art* editor Donald Buchanan.[3]

1. "Statements to Tériade: Matisse Speaks," as cited in Flam 1995, p. 205.
2. Photograph reproduced in Elderfield 1992, p. 296.
3. Buchanan 1950–51, p. 64.

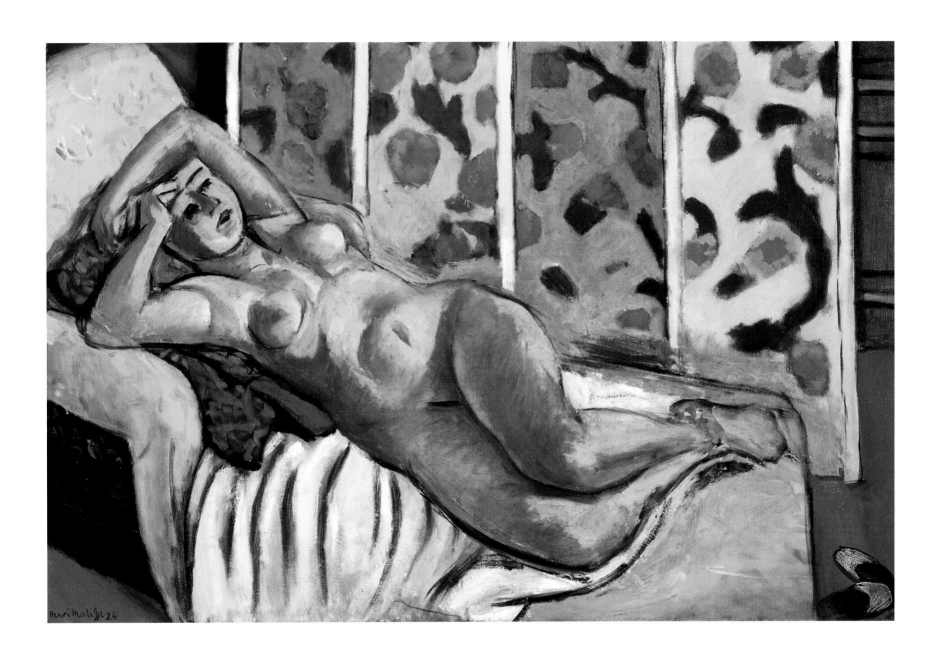

Henri Matisse (French, 1869–1954), *Nude on a Yellow Sofa*, 1926, oil on canvas, 55.1 x 80.8 cm. Purchase, 1958 (6971)
© H. Matisse Estate (Paris) / SODART 2002

This painting by Maurice Prendergast, an American of Canadian birth who trained in Paris from 1891 to 1894, is included in *Post-Impressionist Masterworks* to demonstrate the reach of the movement outside of France and the continuing international importance of Paris as a centre for art education. Prendergast and a twin sister were born in St. John's, Newfoundland, in 1858. Ten years later the family, including a younger brother Charles, moved to Boston, where their father earned a modest income as a confectioner. It is not known what sparked Prendergast's interest in painting, though it may have been the relatively cosmopolitan culture of his new home and the broadened scope of the opportunities available to him. He initially worked as a commercial artist and was also an accomplished watercolour painter.

The Picnic conveys the idyllic message of summertime peace and harmony in a manner suggestive of the calm grandeur of French painter Pierre Puvis de Chavannes, who was admired by the French Post-Impressionists. In 1895 and 1896, after Prendergast returned to America, the Boston Public Library installed Puvis de Chavannes' murals, depicting the disciplines of poetry, philosophy, and science, above the grand staircase. While reflecting the allegorical sensibility of Puvis, *The Picnic* reveals Prendergast's maritime roots in its placement of classical figures, not in an imaginary Arcadia, but in a landscape that recalls a Newfoundland fishing village. The painting is executed with emphasis on contrasting primary colours and a method of outlining form for the insertion of colour known as Cloisonism, a style favoured by the Synthetist followers of Gauguin.

As an example of how modern art could be applied to decoration, *The Picnic* was included in an exhibition on this theme at the Montross Gallery, New York, in April–May 1915.[1] The same year it was purchased by New York lawyer John Quinn, an important collector of early European and American modernism.[2] In 1918, Prendergast would write Quinn that he was "everlastingly grateful" to him for the support he had shown over the years[3] (a catalogue of Quinn's collection after his death in 1924 lists nineteen paintings and watercolours, including the present work and two large decorative works each measuring 7 x 10 feet that had also been exhibited in 1915).[4] Purchased by the National Gallery of Canada in 1940, *The Picnic* represents the earliest acquisition included in *Post-Impressionist Masterworks*.

1. "In the Galleries," *The International Studio,* vol. 45, no. 220 (June 1915), p. 133.
2. Nancy M. Mathews, *Maurice Brazil Prendergast. Charles Prendergast. A Catalogue Raisonné* (Williamstown: Williams College Museum of Art, 1990), p. 294.
3. Maurice Prendergast to John Quinn, 3 February 1918, as cited in Judith Zilczer, *"The Noble Buyer": John Quinn, Patron of the Avant-Garde* (Washington: Smithsonian Institution Press, 1978), p. 37.
4. *John Quinn 1870–1925: Collection of Paintings, Watercolors, Drawings and Sculpture* (Huntington, N.Y.: Pidgeon Hill Press, 1926), p. 25.

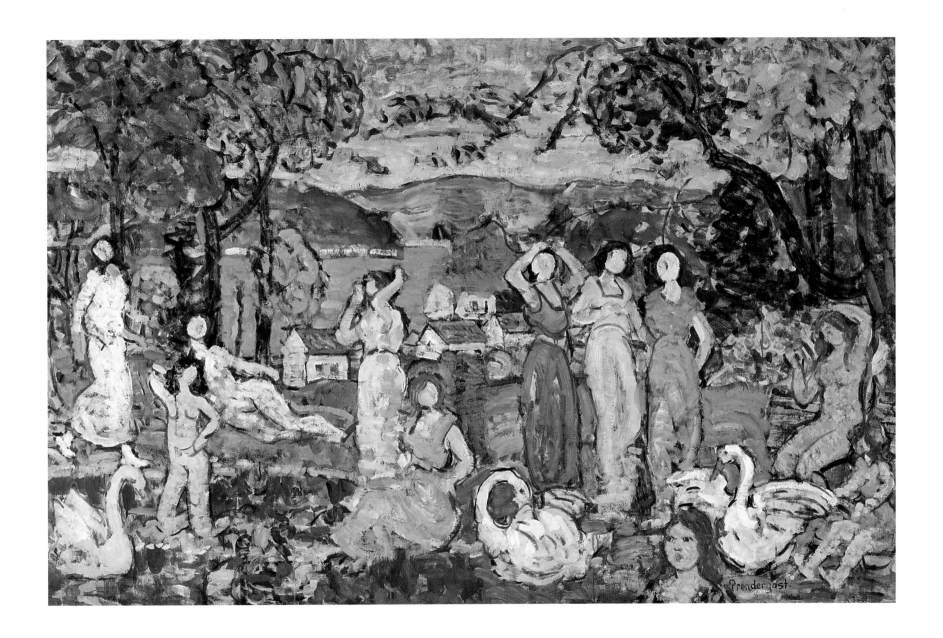

Maurice Prendergast (American, 1859–1924), *The Picnic*, 1915, oil on canvas, 94 x 144.8 cm. Purchase, 1940 (4528)

Soon after Sérusier's birth in Paris in 1864, his father would become director of the perfume and glove manufacturer Houbigant, ensuring his son's financial future. Accomplished in academic studies, Sérusier began his art training at the Académie Julian in 1885. He gained the admiration of fellow students when his *Tisserand* (Weaver) was given an "honourable mention" at the Paris Salon in 1888. While he was painting under Gauguin's guidance in the "Bois d'Amour" near Pont-Aven in October 1888, Sérusier's style took a radical turn towards Synthetism, when he produced the small landscape known as *The Talisman*. This defining work of the movement is remarkable for its flat planes of strong primary colour "straight from the tube" that were to reflect the artist's emotional response to nature.[1] Sérusier returned to Paris inspired by Gauguin's aesthetic theories, and initiated a group of followers he called the Nabis, a Hebrew word meaning "prophets."

Given the popularity of Pont-Aven as an artist colony, Sérusier's meeting with Gauguin in October 1888 was probably not his first visit to the village. It was at this time that he probably met another of Gauguin's followers, the Dutch painter Meyer de Haan, whose carved bust by Gauguin was incorporated into a decorative project for the dining room of the Inn at Le Pouldu – a project that Sérusier himself would contribute to on his return to Brittany in the summer of 1890.[2] Soon after Sérusier's arrival in Pont-Aven in July 1890, Gauguin wrote to Émile Bernard: "Sérusier has arrived and talks only of his evolution [as an artist]. He counts on becoming the student leader of Lefebvre's class [Jules Lefebvre was a professor at the Académie Julian] and converting all those around him, or so he tells me; I have seen nothing that he has worked on."[3] Despite Gauguin's suggestion of a slow start, the summer of 1890 would prove to be a productive one for Sérusier. Influenced by Gauguin's Synthetist style, Sérusier's paintings were dominated by the labours of Breton peasants, including the two men quarrying rock in *Landscape at Pont-Aven*.

With *Landscape at Pont-Aven*, Sérusier achieves a strong Synthetist colourist effect while remaining more or less true to the actual appearance of the quarry's bright contours. The intense yellow-orange colour of the quarry provides a strong primary contrast with the blue sky above. Wearing loose white shirts, blue work pants, wooden clogs, and hats to protect them from the hot summer sun, the two men use a sledge hammer to break apart rock within the broad expanse of excavated terrain. Their modest undertaking is at odds with the scale of mining that apparently took place here at one time. It is difficult to say what kind of stone the men are cutting. While the quarries of grey granite around Pont-Aven were an important source of building and paving stones in the surrounding region, this material is not compatible with most of the ground colour seen in Sérusier's painting.[4] Sérusier continued his annual painting visits to Brittany after Gauguin's departure for Tahiti in 1891, eventually moving to the Breton village of Châteauneuf-du-Faou in 1904.

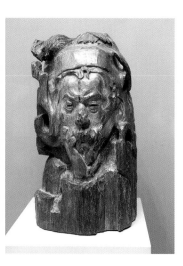

Paul Gauguin, *Portrait of Meyer de Haan*, c. 1889–90, oak with touches of colour, 58.4 cm high. Purchase, 1968 (15310)

1. Maurice Denis, "L'influence de Paul Gauguin," *L'Occident*, no. 23 (October 1903), as cited in Bouillon 1993, p. 74.
2. Robert Welsh, "Le plafond peint par Gauguin dans l'auberge de Marie Henry, au Pouldu," in *Le chemin de Gauguin: Genèse et Rayonnement* (Saint-Germain-en-Laye: Musée Prieure, 1985), p. 124.
3. Maurice Malingue (editor), *Lettres de Gauguin à sa femme et ses amis* (Paris: Éditions Bernard Grasset, 1946), p. 197.
4. "Finistère. État économique du département," *La Grande Encyclopédie*, vol. 17 (Paris: H. Lambrault, 1886–1902), p. 495.

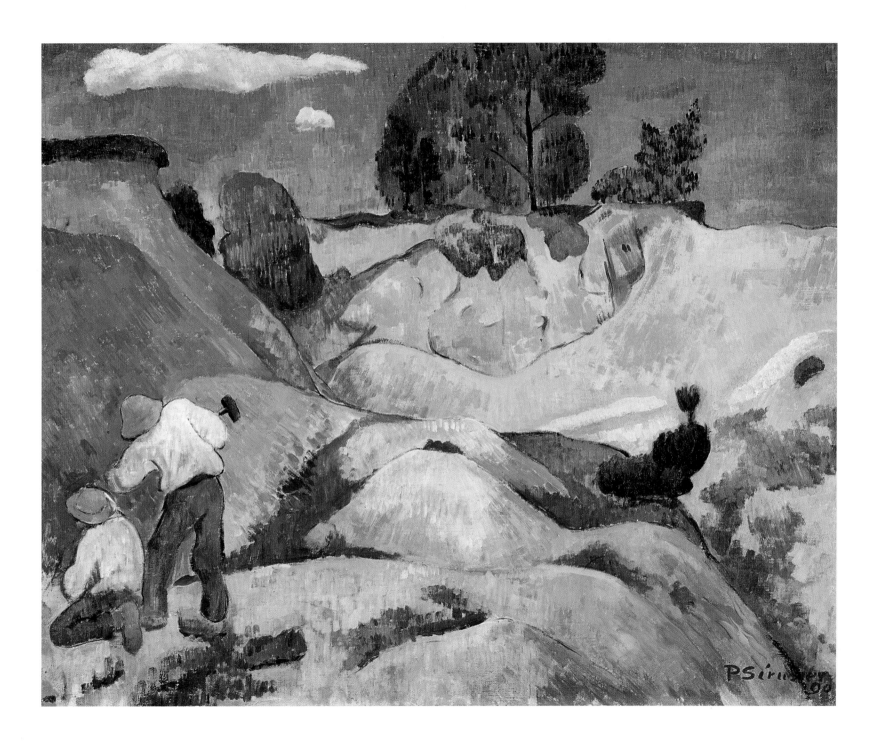

Paul Sérusier (French, 1863–1927), *Landscape at Pont-Aven*, 1890, oil on canvas, 65.3 x 80 cm. Purchase, 1953 (6093)

Walter Sickert, *Noctes Ambrosianae*, 1906, etching and acquatint on wove paper, 32 x 45 cm. Purchase, 1932 (4075)

In 1868 Walter Sickert emigrated with his family to London from Munich, where his Danish father worked as an illustrator. In Britain, Sickert became an influential disciple of French modernism, and his ensuing interest in Impressionism and Post-Impressionism led him to establish the exhibiting society Camden Town Group in the spring of 1911. Earlier the same year he wrote a review of the first Post-Impressionist exhibition organized by Roger Fry at the Grafton Galleries in London. He sang the praises of Cézanne and Gauguin and valued the appearance of the "deformation or distortion" that was a necessary quality in hand-made art, an idiosyncratic linking of the teachings of John Ruskin and French Synthetism that encouraged a greater subjectivity of expression.[1]

After just three months at the Slade School of Art in London, Sickert left to become the student and assistant of James McNeill Whistler in January 1882. Asked to accompany Whistler's *Portrait of the Artist's Mother* to the Paris Salon of 1883, Sickert took the opportunity a trip to Paris afforded to introduce himself to the French Impressionist Edgar Degas. He returned filled with enthusiasm for Degas's work. In December 1889 Sickert organized the "London Impressionists" exhibition, after his colleagues at the New English Art Club had expressed dissatisfaction with his looser brushwork and ribald music-hall subject matter. Sickert denounced the Realist aesthetic of the Club in the catalogue of "London Impressionists," and claimed that "the most fruitful course of study lies in a persistent effort to render the magic and the poetry which they daily see around them."[2]

The National Gallery of Canada's *The Old Bedford: Cupid in the Gallery* is the largest of three versions of the subject of plainly clothed men wearing bowler hats who sit enraptured by the performance below. Some lean forward, while others stand for a better view. With its steep angle of vision and tightly cropped portrayal of the scene, Sickert's composition recalls Degas's many café-concerts and dance performances. Despite the low ambient light of the *Old Bedford: Cupid in the Gallery*, it shows

striking colour contrasts between the pale green of the ceiling and the red, blue, and orange tones that highlight the interior decoration.

The Bedford Music Hall was built in 1861 near Regent's Park, in the working-class district of London known as Camden Town. Sickert regularly attended performances here and at other London music halls, such as the Middlesex on Drury Lane, whose audience is the subject of a print, *Noctes Ambrosianae*, 1906. Music halls, in fact, became his preferred subject of modern life and were portrayed with a certain social conscience. One of the artist's biographers described the typical audience members in these establishments: "The patrons were a tough lot, and if the performance didn't catch on the wretched artist was lucky if over ripe tomatoes were all he had thrown at him."[3] Given the gruff and shady bunch portrayed by Sickert in *The Old Bedford: Cupid in the Gallery*, any performer would certainly have been prudent to attempt to remain in their favour. Indeed, the subtitle may be a veiled metaphor for such rowdiness, inspired by the popular vaudeville song "The Boy I Love Is up in the Gallery." Note also that plaster cupids can be seen to be part of the Gallery décor to the left of the seats. The Old Bedford was torn down in 1898 and replaced by a larger, modernized music hall a year later. Sickert's etchings of the Old and New Bedford, after his paintings of the interior views of both, were published in 1915.

1. Walter Sickert, "The Post-Impressionists," *Fortnightly Review* (January 1911), as cited in O. Sitwell, *A Free House! Or The Artist As Craftsman, Being The Writings Of Walter Richard Sickert* (London: MacMillan & Co., 1947), p. 102.
2. Robert Emmons, *The Life and Opinions of Walter Richard Sickert* (London: Faber and Faber Ltd., [1941]), p. 99.
3. Ibid., p. 47.

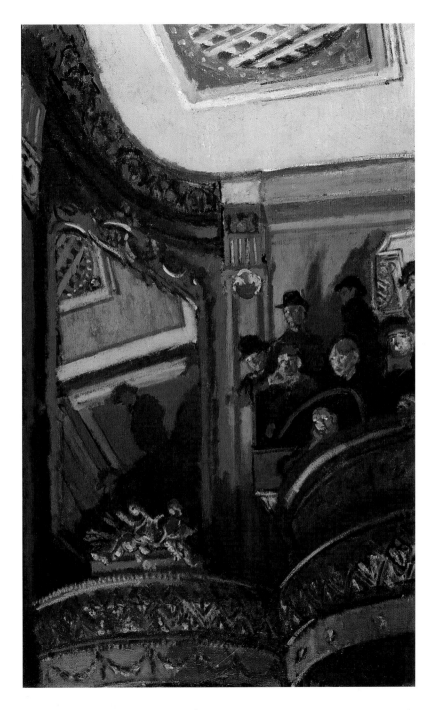

Walter Sickert (British, 1860-1942), *The Old Bedford: Cupid in the Gallery*, 1894-95,
oil on canvas, 126.5 x 77.5 cm. Gift of the Massey Collection of English Painting, 1946 (4810)

Maurice de Vlaminck, *Saint-Adrien*, c. 1913, woodcut on laid paper, 49.5 x 48.5 cm. Purchase, 1961 (9704)
© Estate of Maurice de Vlaminck / SODRAC (Montreal) 2002

Vlaminck, the quintessential eccentric, seemed early in life to be set for an unconventional career. He was born in April 1876 to musician parents near Les Halles in Paris. He married in 1894 and, obsessed with cycling, raced professionally to support his family in addition to teaching violin. All the while he continued to paint and draw, even though he had little academic artistic training. During a leave from military service in July 1900, he met André Derain, and after his decommission in September of that year, rented a studio with Derain on the Ile-de-Chatou, near Paris.

From 1900 until 1910 Vlaminck's landscape subjects were limited to Chatou and its surroundings. He participated with the group of artists around Matisse who earned the name Fauves (Wild Beasts) at the Third Salon d'Automne in 1905, and he began exhibiting at the Salon des Indépendants the same year. Vlaminck was also a prolific, if not entirely gifted, writer of novels, poetry, and rambling autobiographical essays. He described his instinctual approach to painting during the Fauve years as follows: "With my blues and reds I wanted to set fire to the Ecole des Beaux-Arts, and to translate my feelings onto canvas without thinking about what was being painted."[1]

Although dated 1908 on the back of the canvas, the *Locks at Bougival* was more likely painted in 1906 or 1907, when Vlaminck's palette was at the peak of its chromatic intensity. After seeing the Cézanne retrospective at the Salon d'Automne in 1907, he made a dramatic shift in style: the striking primary colours of his earlier landscapes gave way to muted greens and browns and, influenced by Cubism, Vlaminck began showing a greater concern for structure and geometry, a tendency that one can clearly see in his prints of the period. Bougival is located across the Seine from Chatou. Now incorporated into the greater urban area of Paris, during the 1870s and 1880s Bougival was a popular destination for Parisians seeking an escape from the city and an opportunity for swimming, boating, and dancing. In contrast to its portrayal as an idyllic site of leisure by the Impressionists, however, Vlaminck's painting concentrates on the everyday lives of the townsfolk living along the locks that were an important link in the commercial waterway of the Seine. By looking inward to the everyday experience of the townsfolk themselves, Vlaminck transforms the dull autumn routine of small-town life in Bougival into a fireworks display of primary colours.

In April 1906 the dealer Ambroise Vollard purchased the contents of Vlaminck's studio and contracted with the artist to purchase future paintings, and in 1907 Vollard began to handle Vlaminck's submissions to the Salon d'Automne.[2] *The Locks at Bougival* may very well have passed through Vollard's hands. By 1914 it was owned by a collecting club based in Paris known as the "Peau de l'Ours" (Bear Skin), which purchased work by Picasso and other avant-garde artists on speculation. In March 1914, prior to the beginning of the First World War in August, *The Locks at Bougival* was included in a large auction of the "Peau de l'Ours" collection at the Hôtel Drouot in Paris.[3]

1. As cited in Florent Fels, *Vlaminck* (Paris: Marcel Seheur, 1928), p. 29.
2. Maurice de Vlaminck, *Dangerous Corner* (London: Elek Books, 1961), p. 75. Translation of *Tournant Dangereux*.
3. *Collection de la "Peau de l'Ours,"* Hôtel Drouot, Paris, Sale Catalogue, 2 March 1914, no. 87.

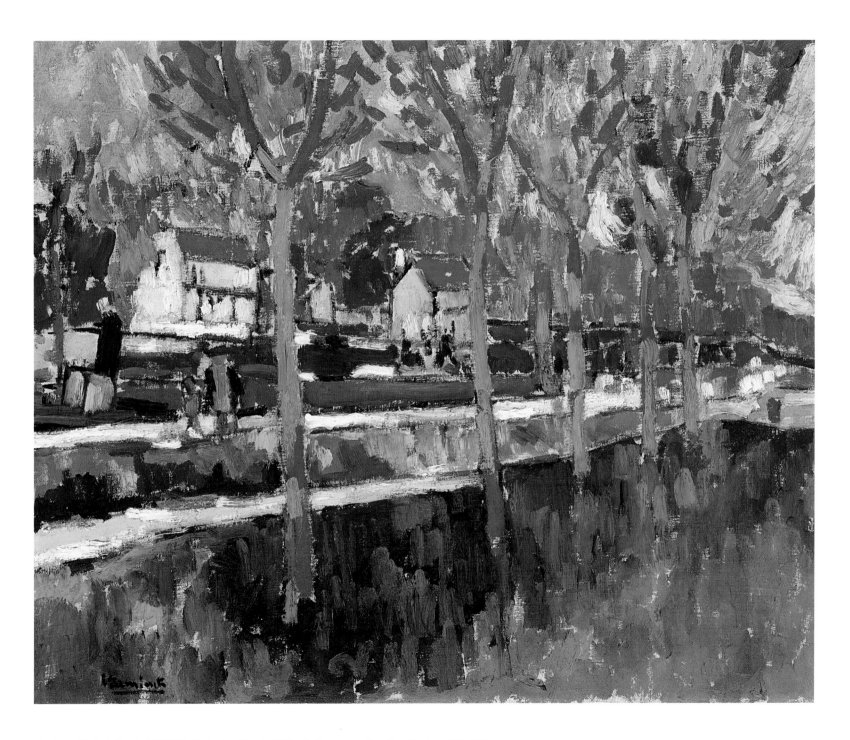

Maurice de Vlaminck (French, 1876–1958), *The Locks of Bougival*, 1906–07, oil on canvas, 54 x 65 cm. Purchase, 1951 (5783)
© Estate of Maurice de Vlaminck / SODRAC (Montreal) 2002

SELECTED REFERENCES

Bouillon, Jean-Paul (editor). *Le ciel et l'Arcadie. Maurice Denis, textes réunis, présentés et annotés*. Paris: Hermann, 1993.

Buchanan, Donald W. "Interview in Montparnasse." *Canadian Art*, volume 8, number 2 (1950-51), pp. 61-63.

Cachin, Françoise, et al. *Cézanne*. Philadelphia Museum of Art, 1996.

Cogeval, Guy. *The Time of the Nabis*. Montreal Museum of Fine Arts, 1998.

Collins, John, and Colin B. Bailey. *Van Gogh's* Irises: *Masterpiece in Focus*. Ottawa: National Gallery of Canada, 1999.

Denvir, Bernard. *Post-Impressionism*. London: Thames and Hudson, 1992.

Druick, Douglas W., and Peter Kort Zegers. *Van Gogh and Gauguin: The Studio of the South*. Chicago: Thames and Hudson, 2001.

Elderfield, John. *Henri Matisse: A Retrospective*. New York: The Museum of Modern Art, 1992.

Flam, Jack. *Matisse on Art*. Berkeley and Los Angeles: University of California, 1995.

Freeman, Judi. *The Fauve Landscape*. Los Angeles County Museum of Art, 1990.

Fry, Roger. "The Post-Impressionists." Introduction to *Manet and the Post-Impressionists*. Grafton Galleries. London: Ballantyne and Company Ltd., 1910.

Homburg, Cornelia. *Vincent van Gogh and the Painters of the Petit Boulevard*. Saint Louis Museum, 2001.

House, John, and MaryAnne Stevens (editors). *Post-Impressionism: Cross-Currents in European Painting*. Royal Academy of Arts, London, 1979.

Jaworska, Wladyslawa. *Gauguin and the Pont Aven School*. London: Thames and Hudson, 1972.

Musée d'art moderne de la ville de Paris. *Van Dongen, le peintre 1877-1968*. Paris: Le Musée, 1990.

Rewald, John. *Post-Impressionism: From van Gogh to Gauguin*. New York: The Museum of Modern Art, 1956.

Rewald, John. *The Paintings of Paul Cézanne*. 2 volumes. New York: Abrams, 1996.

Thomson, Belinda. *The Post-Impressionists*. London: Phaidon Press Ltd., 1990.

Welsh-Ovcharov, Bogomila. *Vincent van Gogh and the Birth of Cloisonism*. Toronto: Art Gallery of Ontario, 1981.

Whitfield, Sarah, and John Elderfield. *Bonnard*. London: Tate Gallery Publishing, 1998.

Wildenstein, Daniel. *Gauguin. Premier itinéraire d'un sauvage. Catalogue de l'oeuvre peint (1873-888)*. 2 volumes. Paris: Wildenstein Institute, 2001.

Zafran, Eric M. (editor). *Gauguin's* Nirvana: *Painters at Le Pouldu 1889-90*. Hartford: Wadsworth Atheneum Museum of Art, 2001.

National Library of Canada Cataloguing in Publication Data

National Gallery of Canada.
Post-impressionist masterworks from the National Gallery of Canada.

Issued also in French under title: Chefs-d'oeuvre post-impressionnistes du Musée des beaux-arts du Canada.
Includes bibliographic references : p. 36.
ISBN 0-88884-755-6

1. Post-impressionism (Art)—Exhibitions.
2. National Gallery of Canada—Exhibitions.
I. Collins, John Bruce, 1957- . II. Title.

ND192 P6 N38 2002 759.05'6
 C2002-986003-2

This publication accompanies the exhibition *Post-Impressionist Masterworks*, presented by the National Gallery of Canada. All works illustrated are from the collection of the National Gallery of Canada unless otherwise noted.

Supported by the Department of Canadian Heritage through the Canada Travelling Exhibitions Indemnification Program

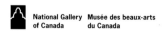 National Gallery of Canada / Musée des beaux-arts du Canada

380 Sussex Dr., Ottawa K1N 9N4 http://national.gallery.ca

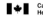 Canadian Heritage / Patrimoine canadien Canadä

Cover: Detail of *Landscape by the Sea: the Côte d'Azur near Agay*, 1905, see p .15